LAND SEA AND SKY

❦

Paintings

of

Rockaway Beach

Broad channel

+

Jamaica bay

Wildlife Sanctuary

*

by

Bob Van Lindt

LAND SEA AND SKY

copyright c 2017 Bob Van Lindt

all rights reserved. no part of this book may be copied

or duplicated in any form , by any means unless written

permission by the author or publisher

*

ISBN # 978-1545061862

*

bob Van Lindt

vanlindtClassics

83-49 Dongan Ave

Suite 2

Elmhurst, N.Y.

11373

*

Member of Rockaway Artist Alliance

Cover & book design by create space

Into page photo of author by Joseph Paul Fox

Cover painting 'Taking a Break" by Bob Van Lindt

www. bobvanlindt.biz

Back Cover Photo by George Ryan

LAND SEA AND SKY

INTRODUCTION

My land sea and sky series on the Rockaways have given me great Challenges, Excitement and Pleasure. To wait for the sunrise, to watch the sunset, see the breaking waves, the ever changing weather. The sky and the clouds in their grandeur. The surfers who challenge the sea, riding atop the crests balancing gloriously in delight.

The loneliness of the beach at times gives ones soul a place of quiet contemplation. The endless surf rolling into our lives with a passionate pulse known only to an individual with his or hers heart, mind and eyes wide open..

This is my Rockaway

Bob Van Lindt

LAND SEA AND SKY

Table of contents

	Page
Cloud Beach	1
Prepping the Lines II	3
Catch of the day	5
Rockaway Wave	7
Rockaway Blue	9
Thinking it over	11
Surfer	13
Rolling Thunder	15
Rockaway Bungalow	17
Taking a Break	19
Lazy Afternoon in the Rockaways	21
Red Sneakers	23
Abandon Outpost-Fort Tilden in the Rockaways	25
Repairs Underway-Post Sandy	27
Done for the Day	29
Sand Castle	31
December Sky	33
Rockaway Christmas	35

January Sky	37
Classic Rockaway	39
Blue House - Red Door	41
New Year's Eve	43
Nightfall on the Peninsula	45
Sunset over the Bay	47
Broad Channel Backdrop	49
Dry Dock	51
Broad Channel Slip	53
Abandoned in the Marsh	55
Jamaica Bay Birch Entrance I	57
Jamaica Bay Birch Entrance II	59
Birch Tree Rhapsody I	61
Birch Tree Rhapsody II	63
Birch Tree Cluster I	65
End of Summer Birches	67
Birch Tree Cluster II	69
Birches in Plein Air	71
Birch Tree Memoirs	73

Cloud Beach

8x10 acrylic on canvas

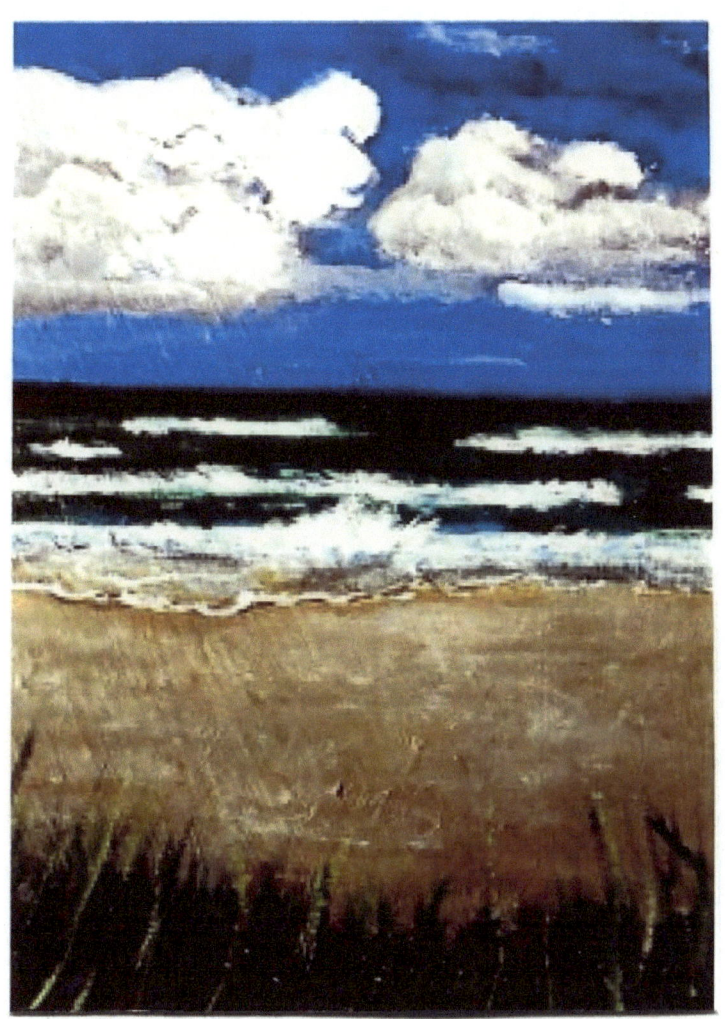

Prepping the Lines II

8x10 acrylic on canvas board

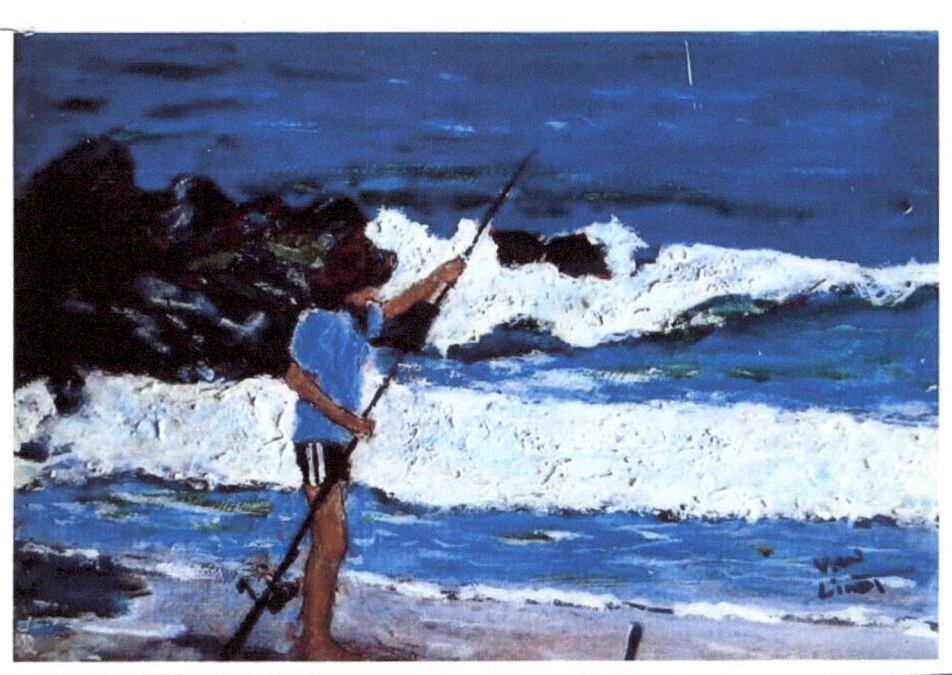

Catch of the Day

8x10 acrylic on canvas board

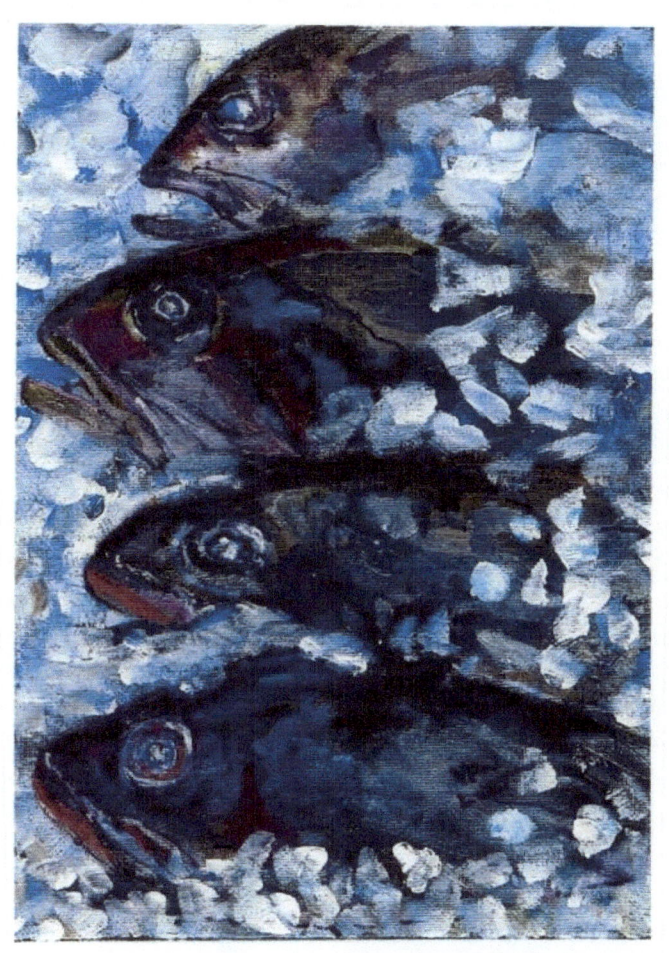

Rockaway Wave

5x7 acrylic on canvas board

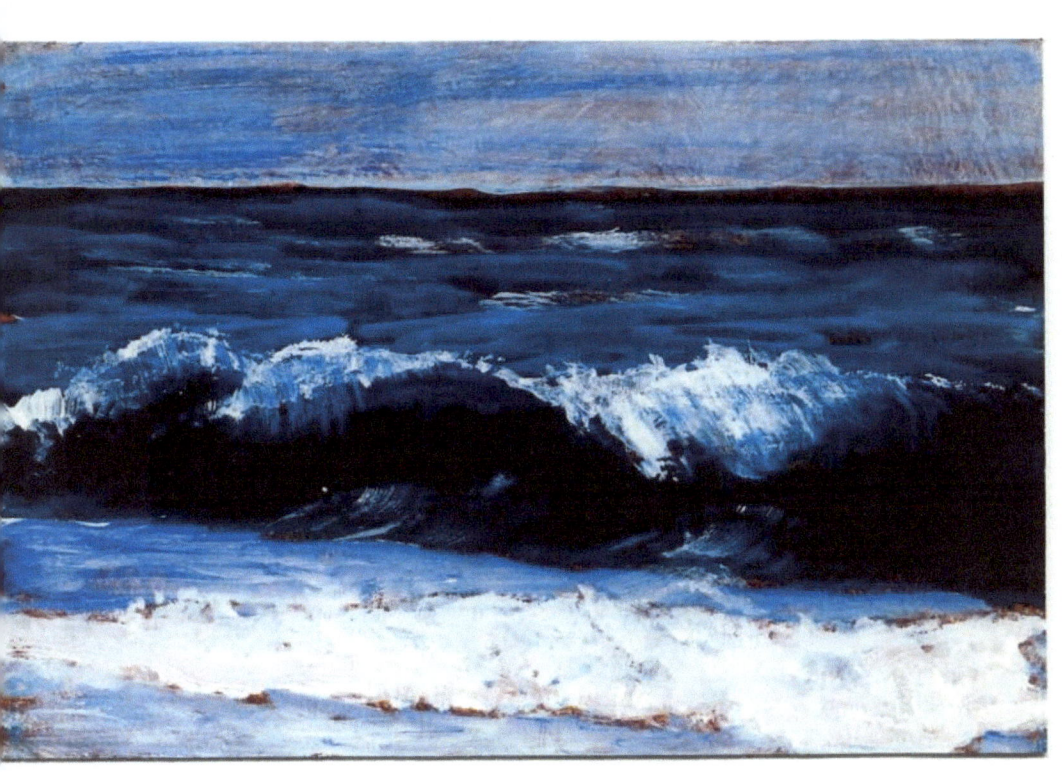

Rockaway Blue

16x20 acrylic on canvas

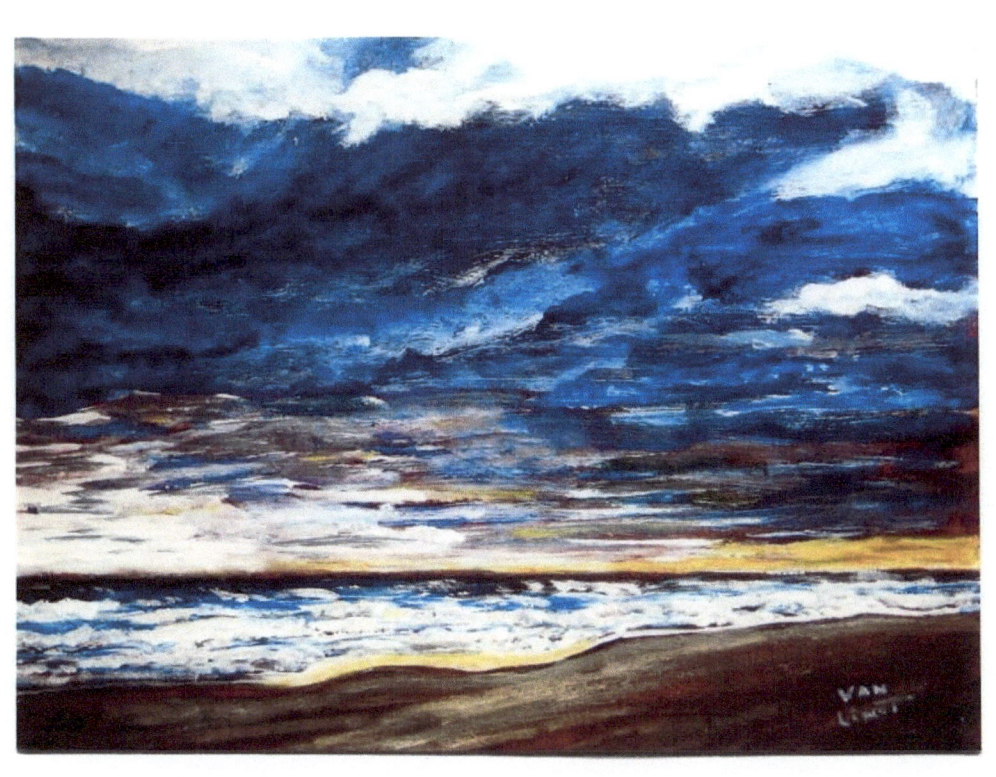

Thinking it Over

8x10 acrylic on panel

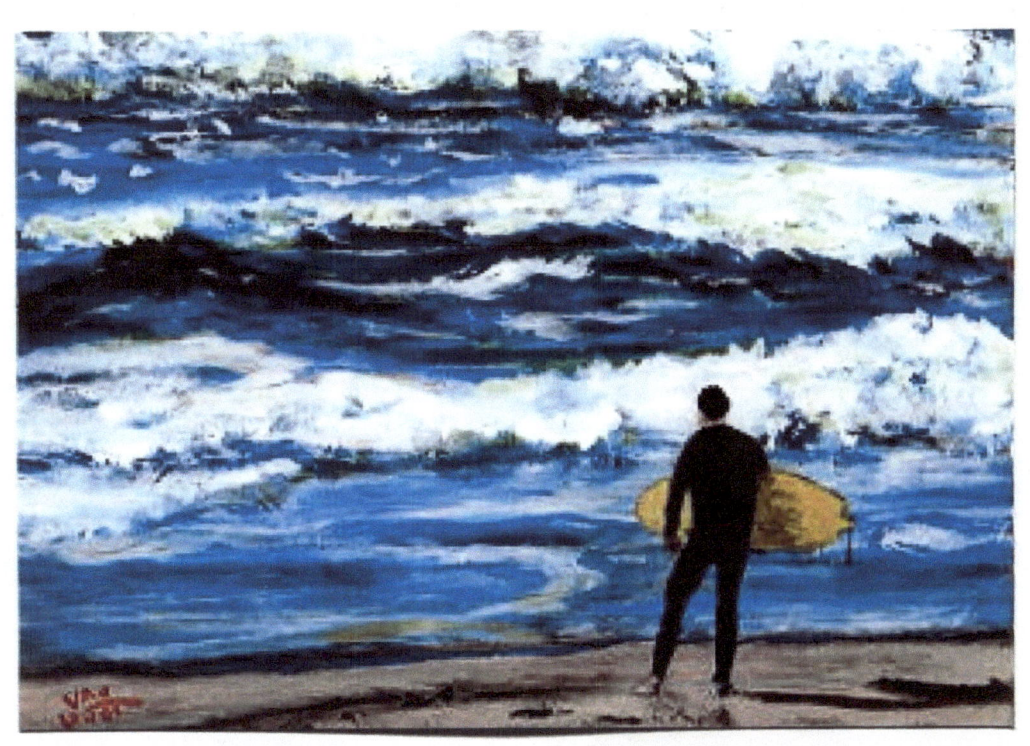

Surfer

8x10 acrylic on panel

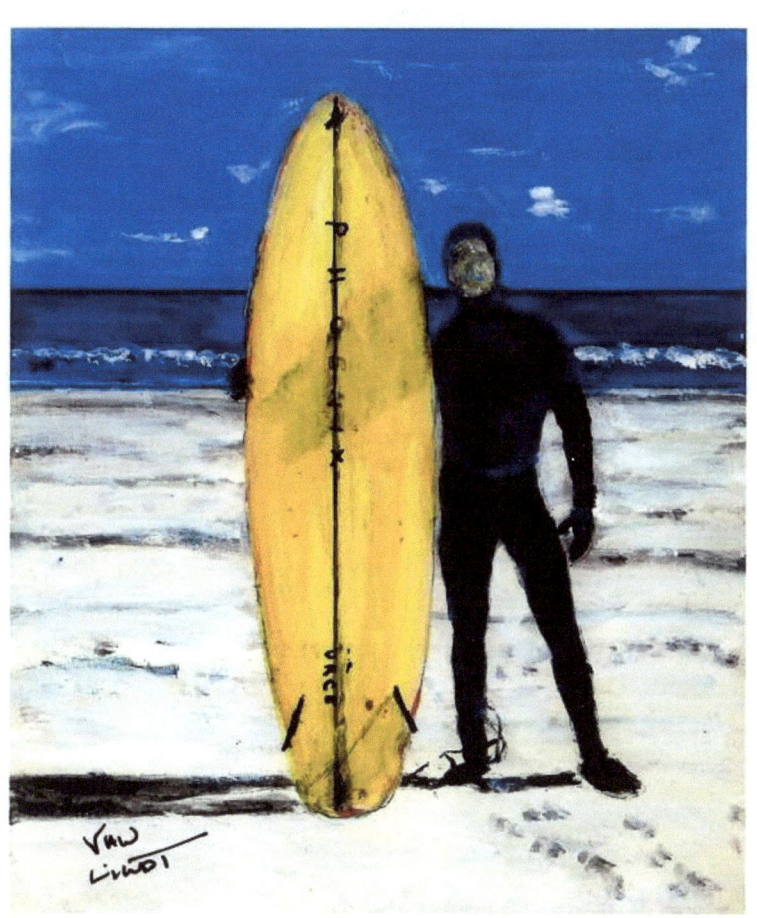

Rolling Thunder

18x24 acrylic on canvas

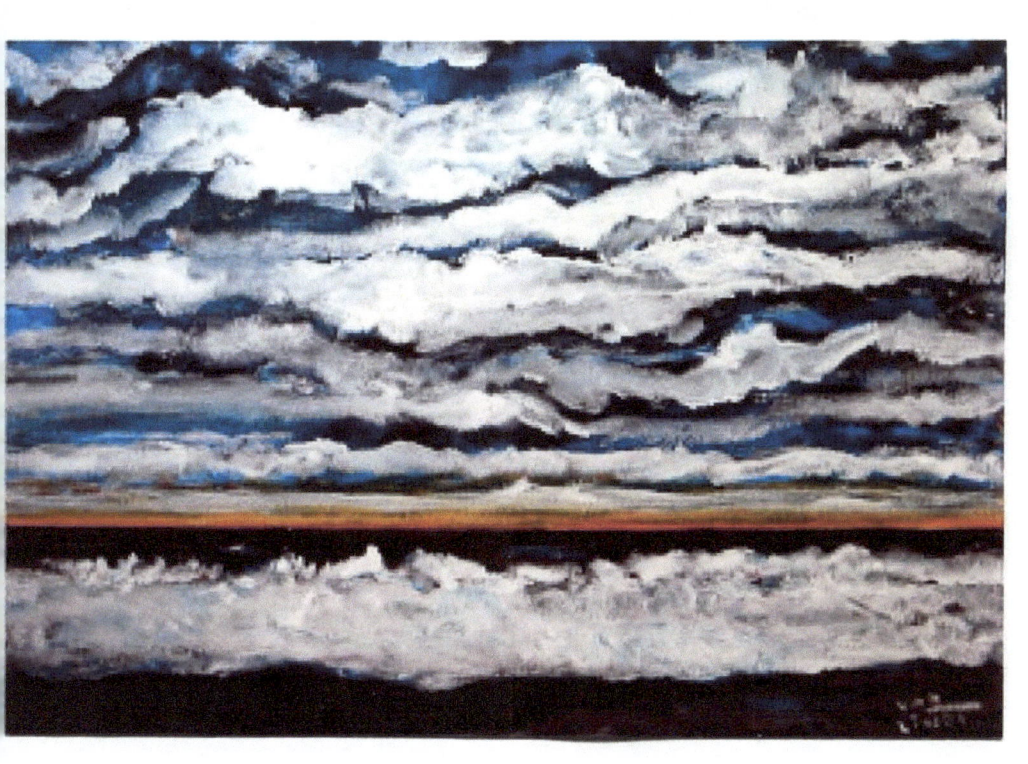

Rockaway Bungalow

5x7 acrylic on panel

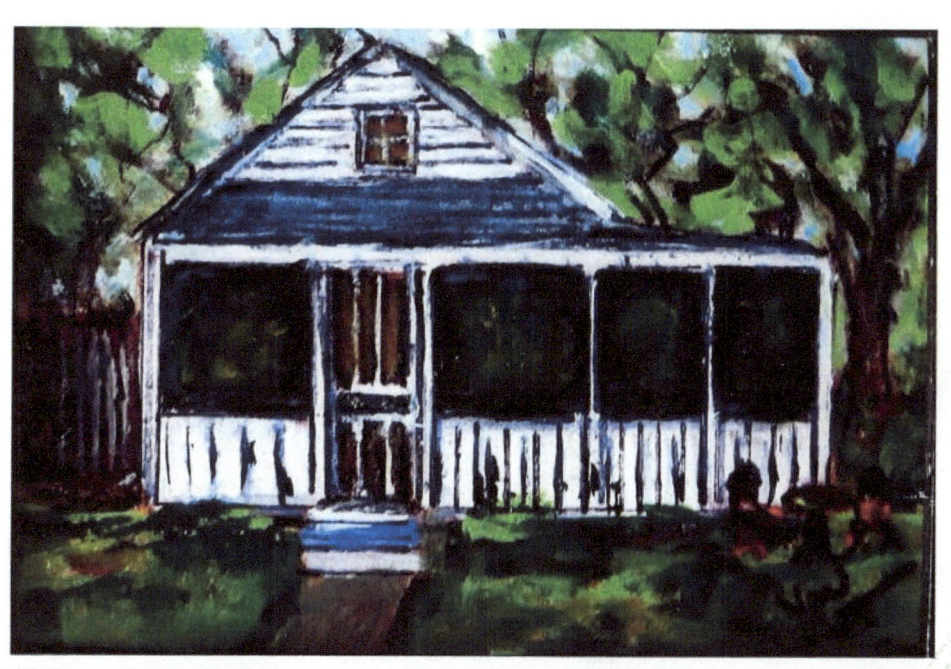

Taking a Break

8x10 acrylic on panel

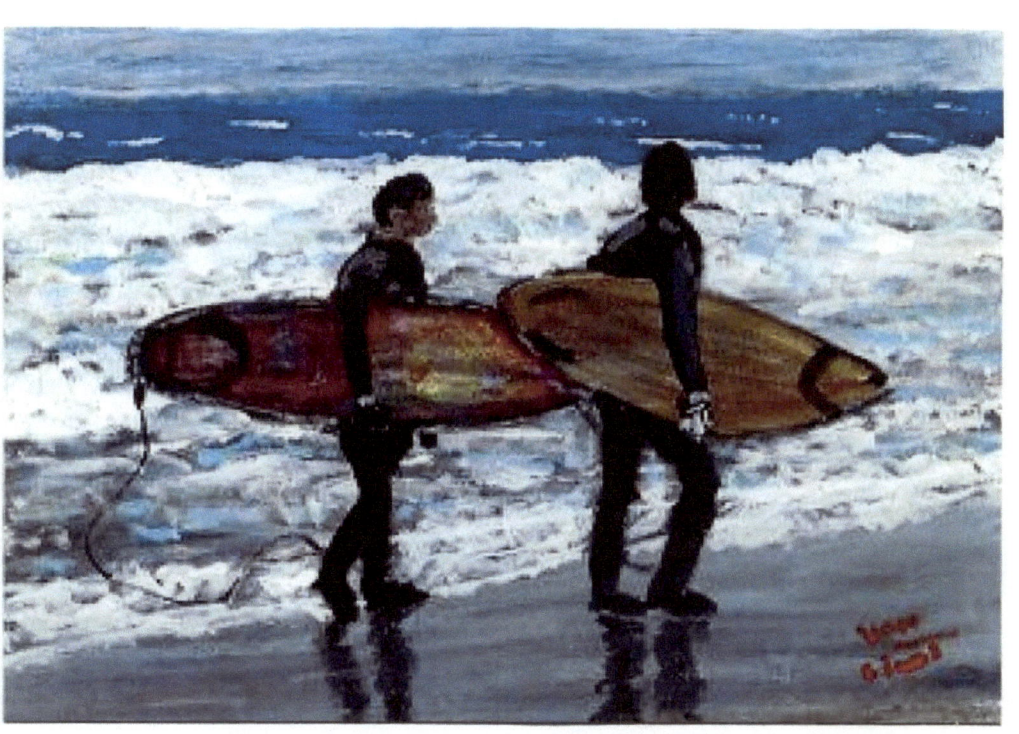

Lazy Afternoon in the Rockaways

9x12 acrylic on panel

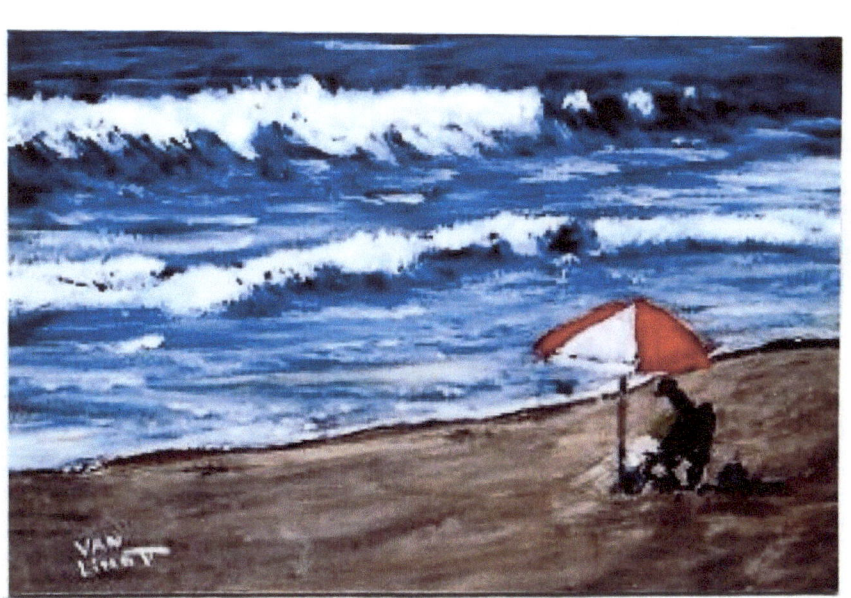

Red Sneakers

8x10 acrylic on panel

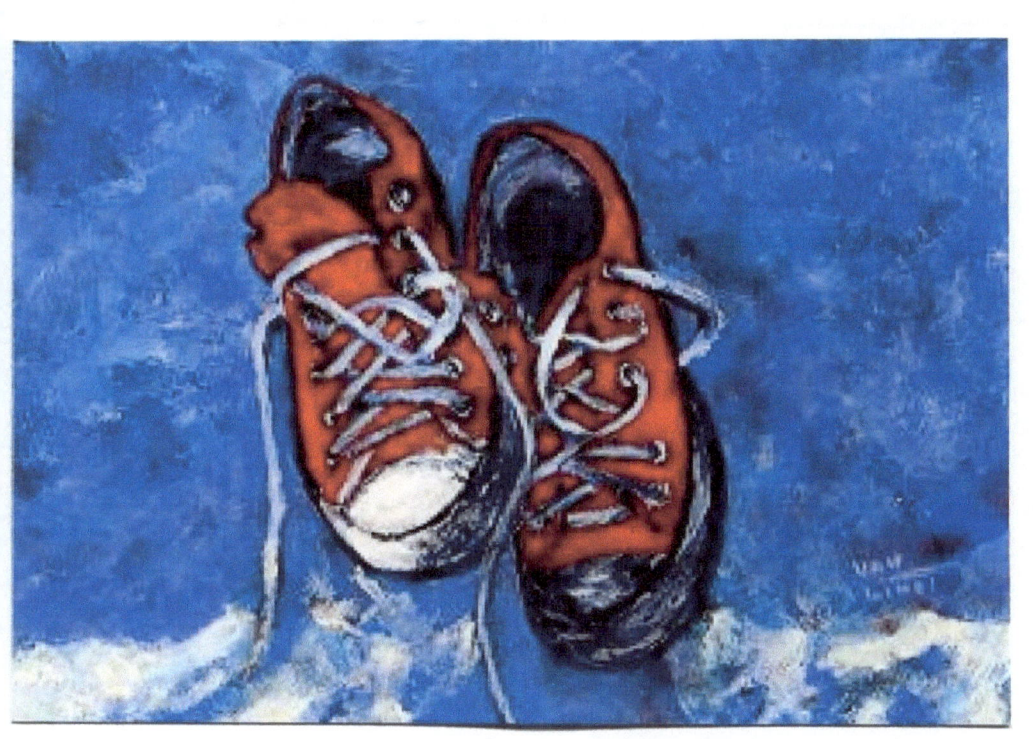

Abandoned Outpost

Fort Tilden in the Rockaways

acrylic on panel

8x10

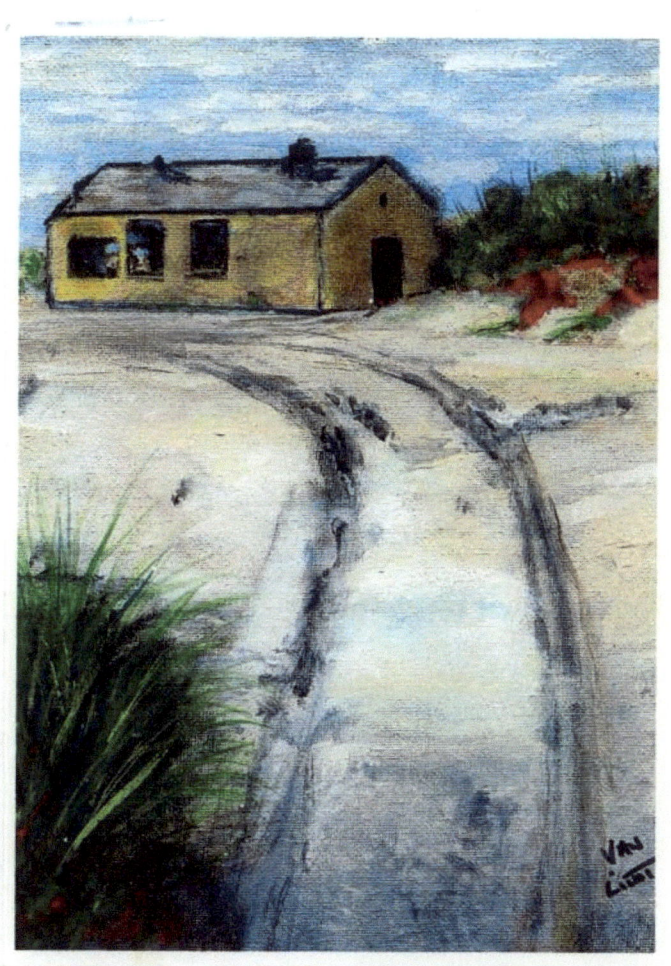

Repairs Underway-Post Sandy

5x7 acrylic on canvas

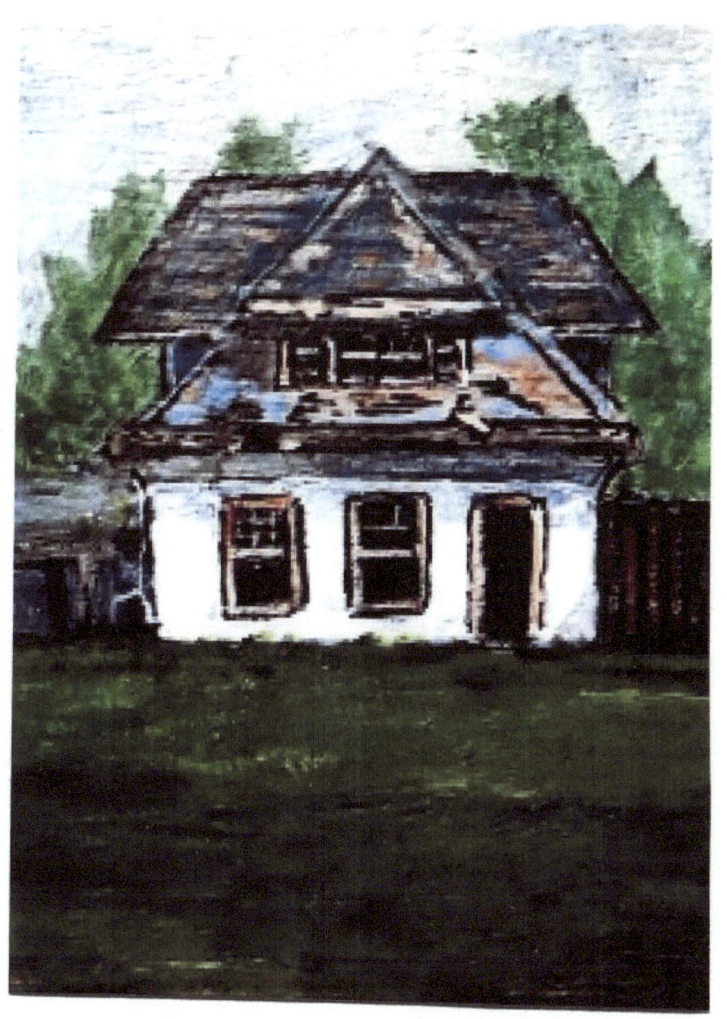

Done for the Day

8x10 acrylic on panel

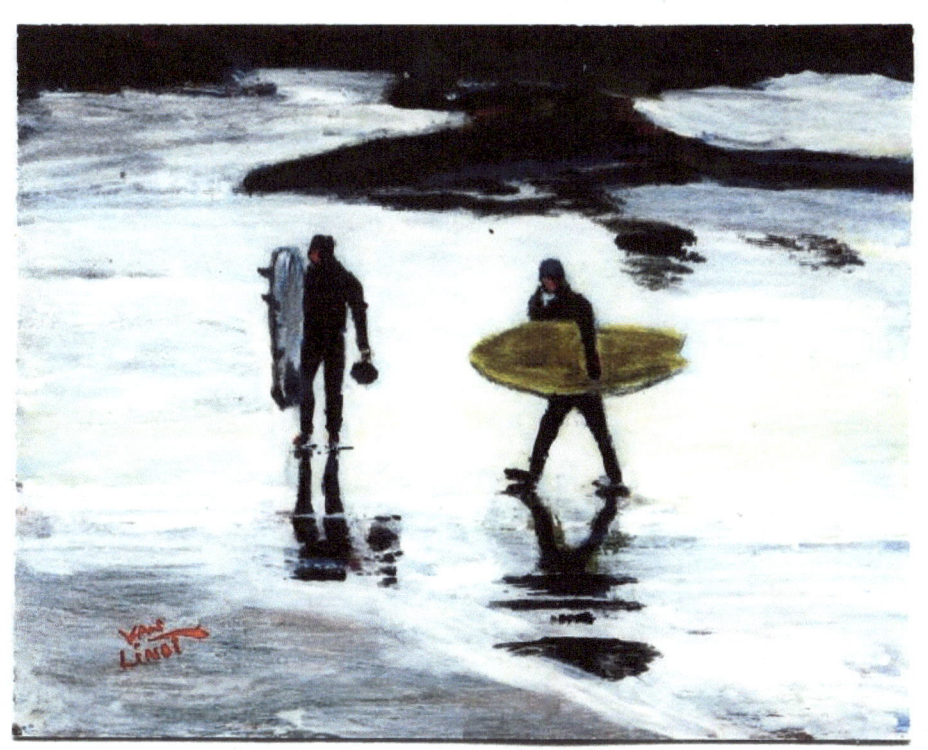

Sand Castle

8x10 acrylic on panel

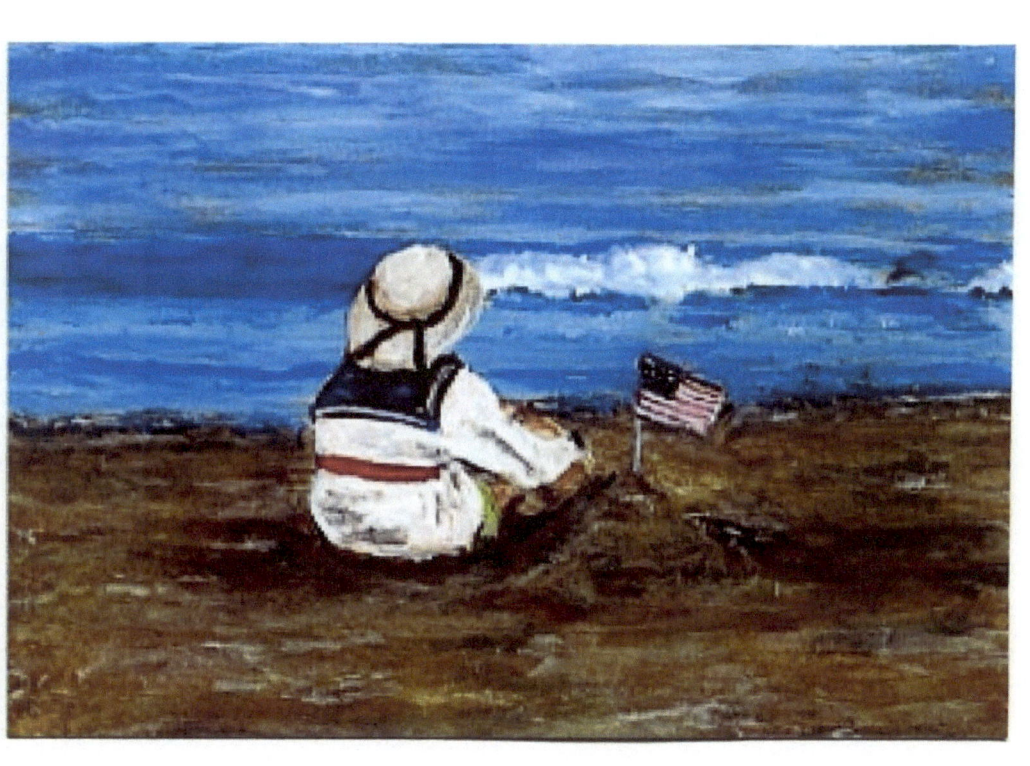

December Sky

acrylic on panel

8x10

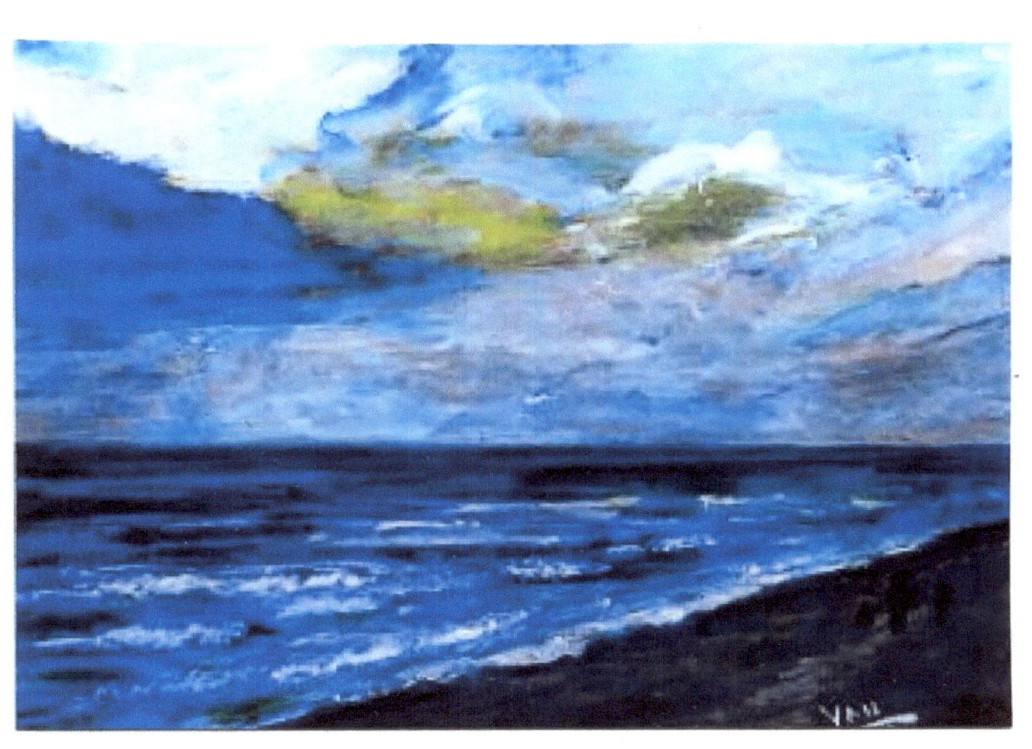

Rockaway Christmas

8x10 acrylic on panel

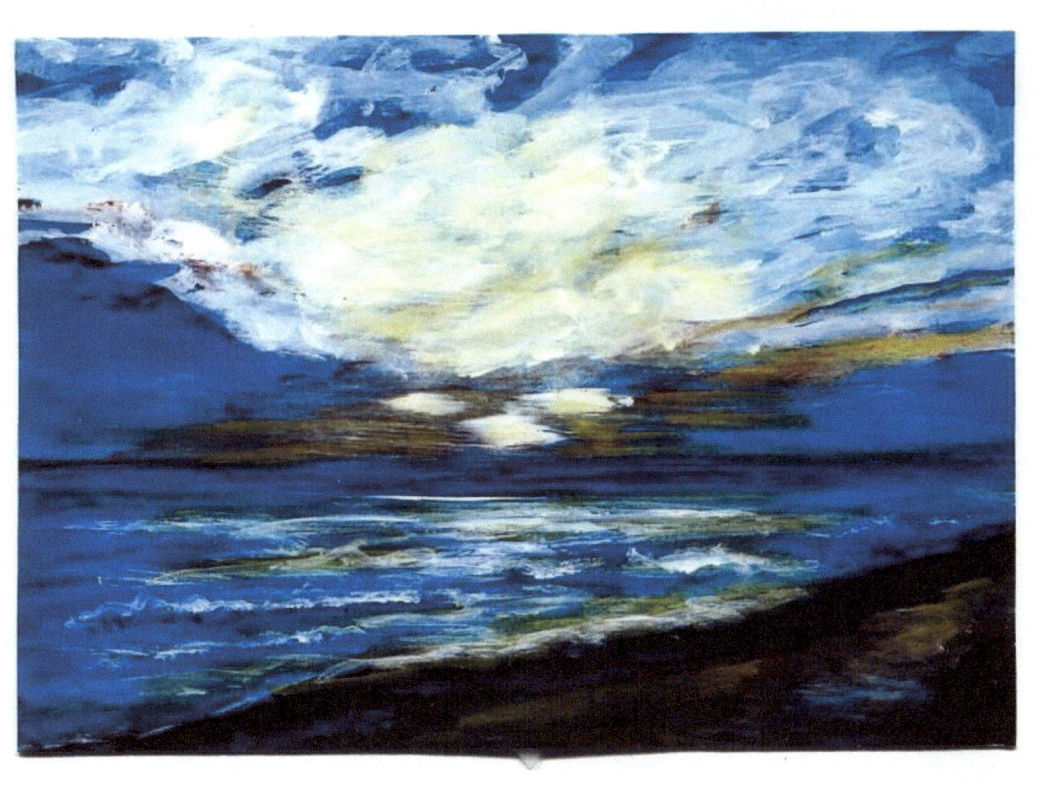

January Sky

8x10 acrylic on panel

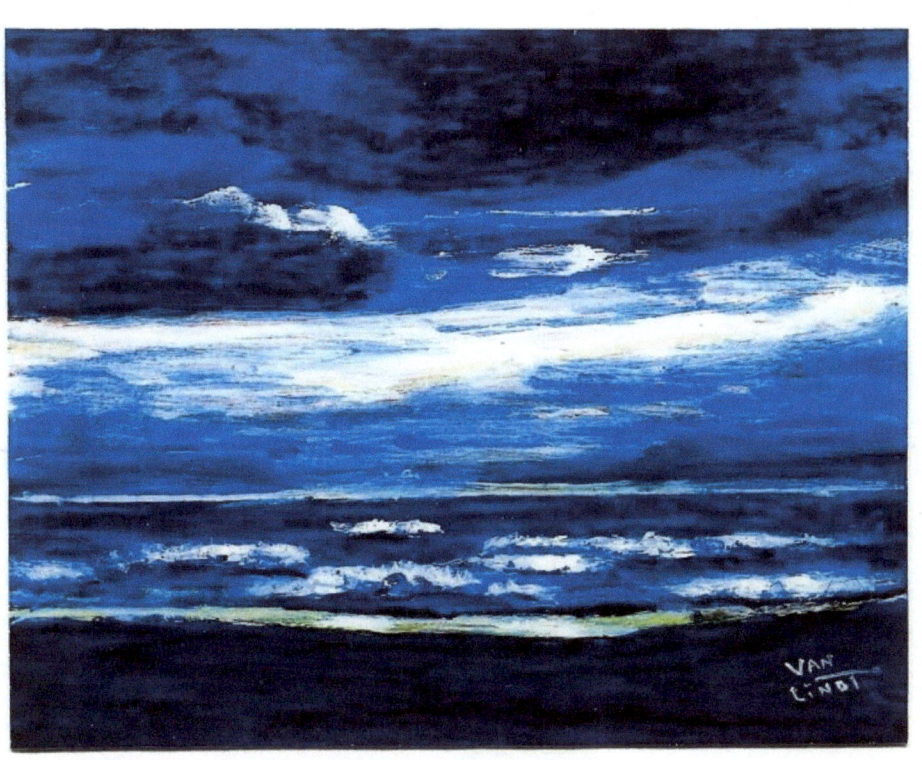

Classic Rockaway 9x12 acrylic on panel

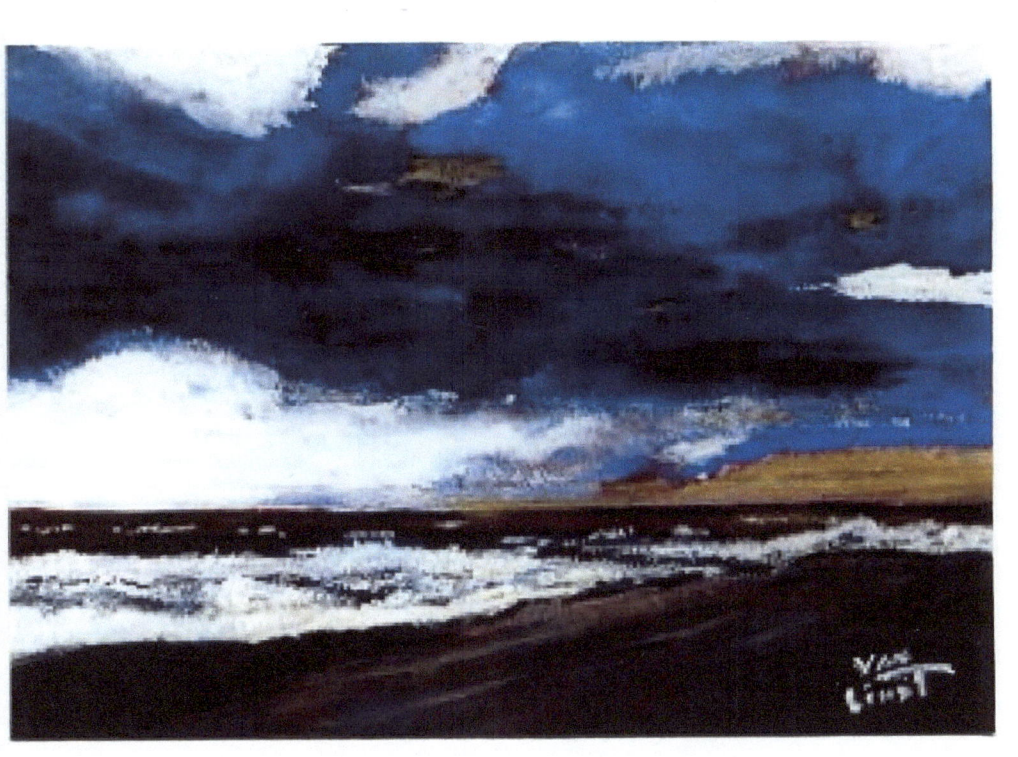

Blue House – Red Door

5x7 acrylic on panel

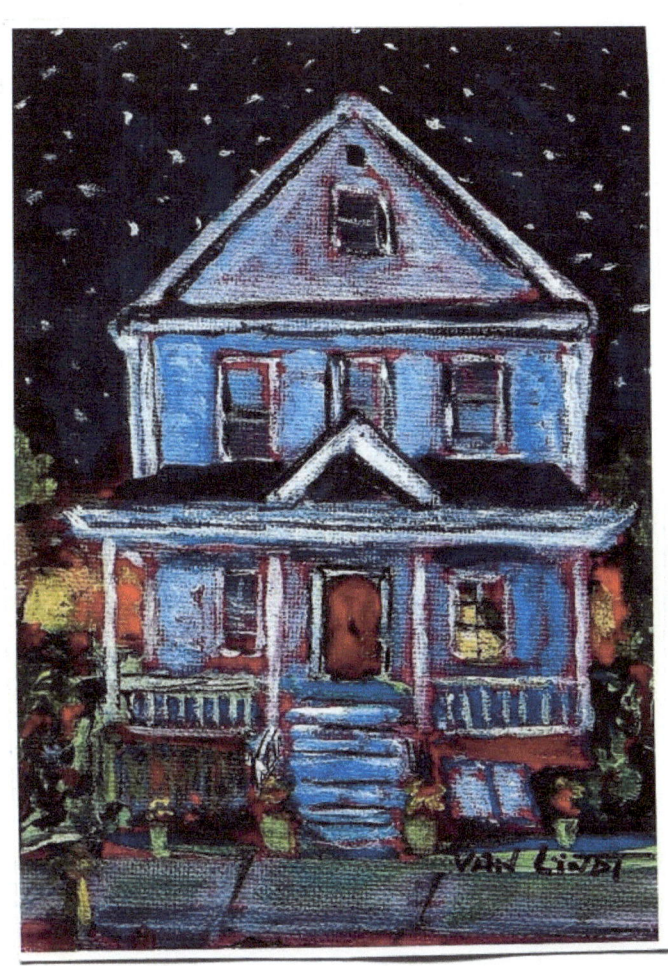

New Year's Eve

8x10 acrylic on panel

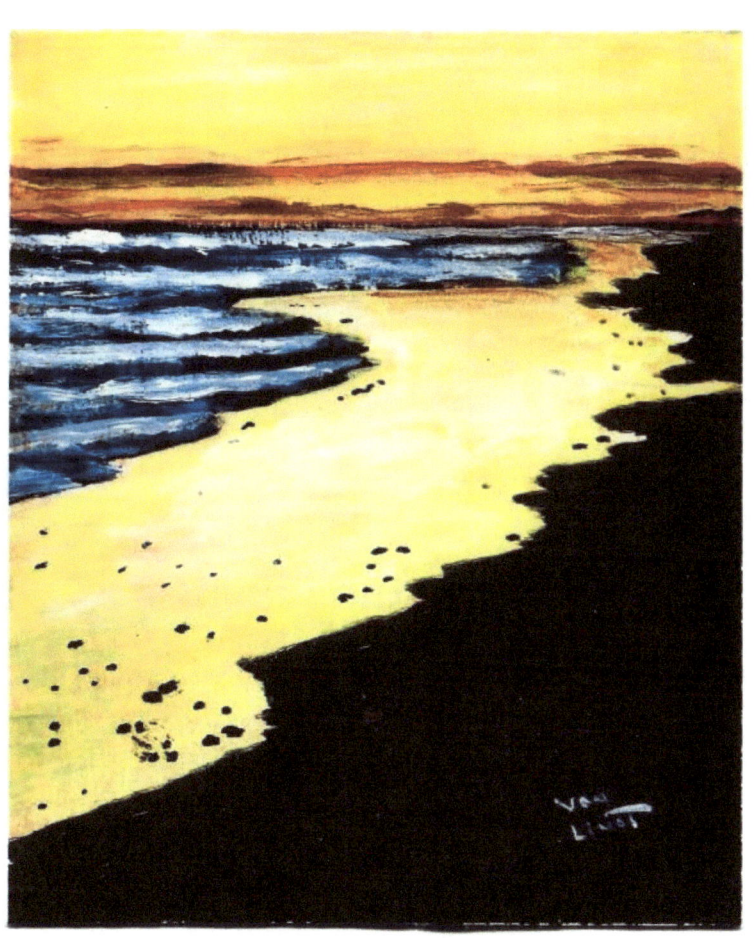

Nightfall on the Peninsula

8x10 acrylic on panel

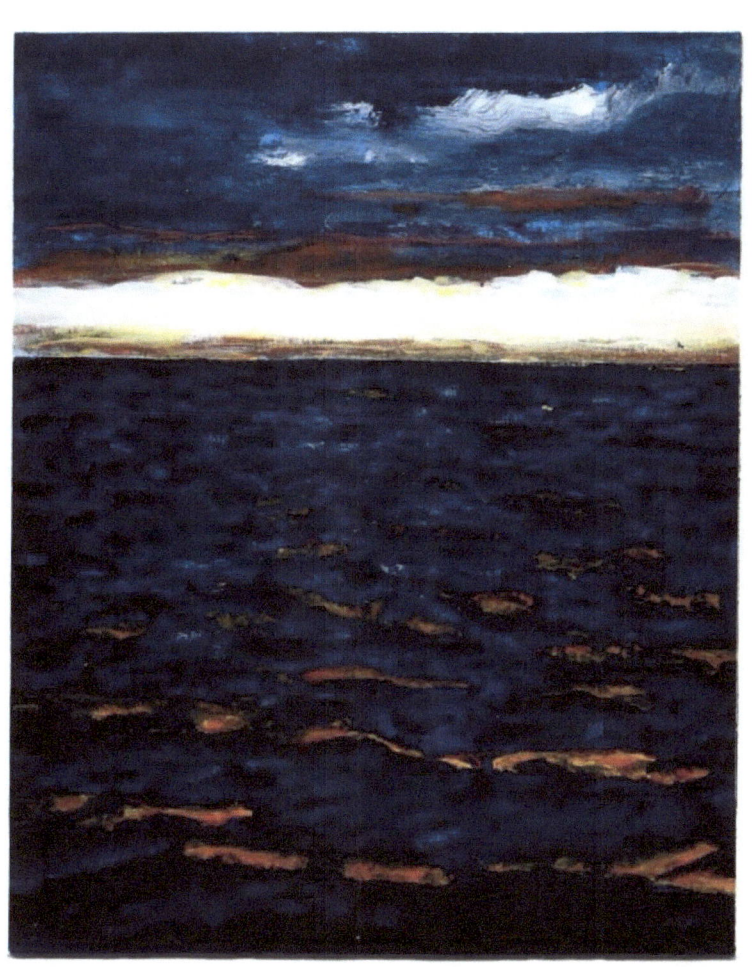

Sunset over the Bay

8x10 acrylic on panel

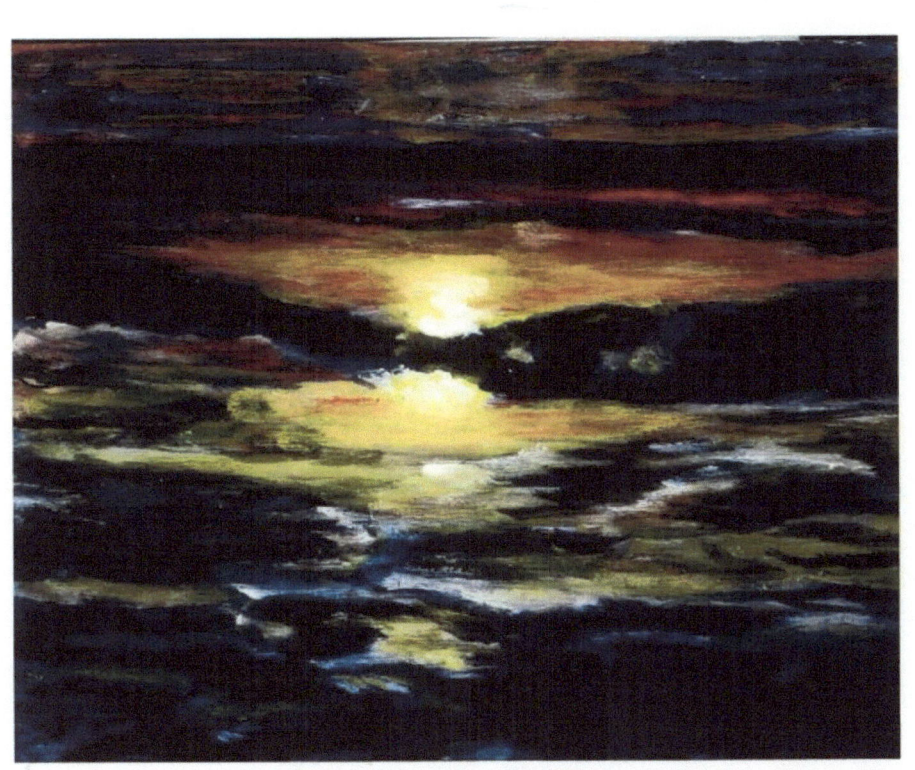

Broad Channel Backdrop

8x10 acrylic on panel

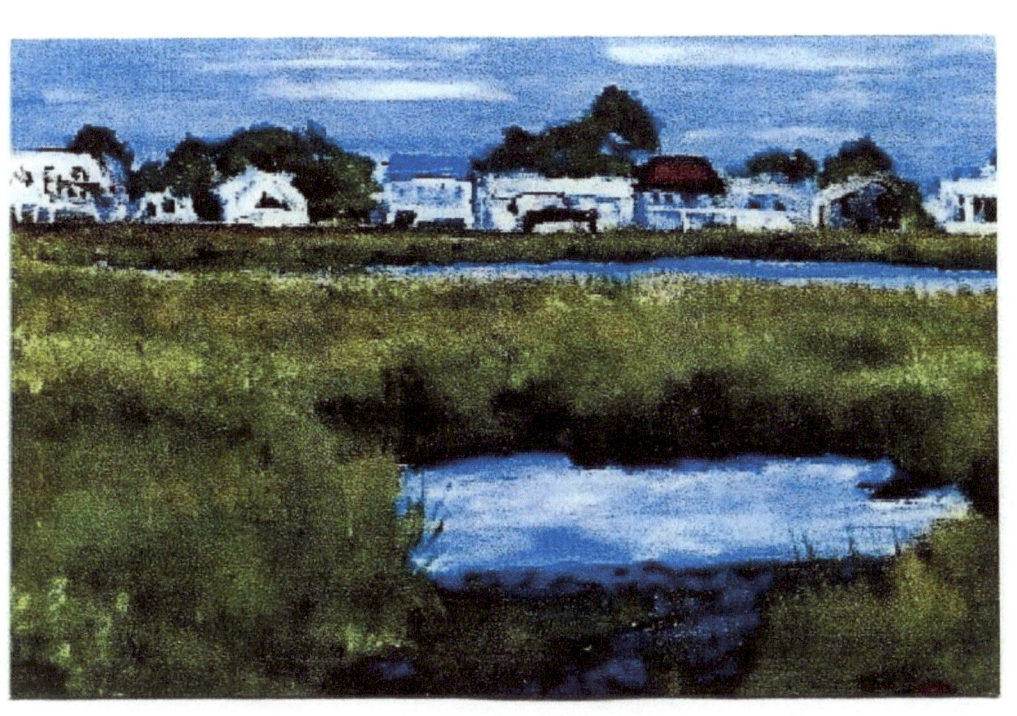

Dry Dock

acrylic on canvas

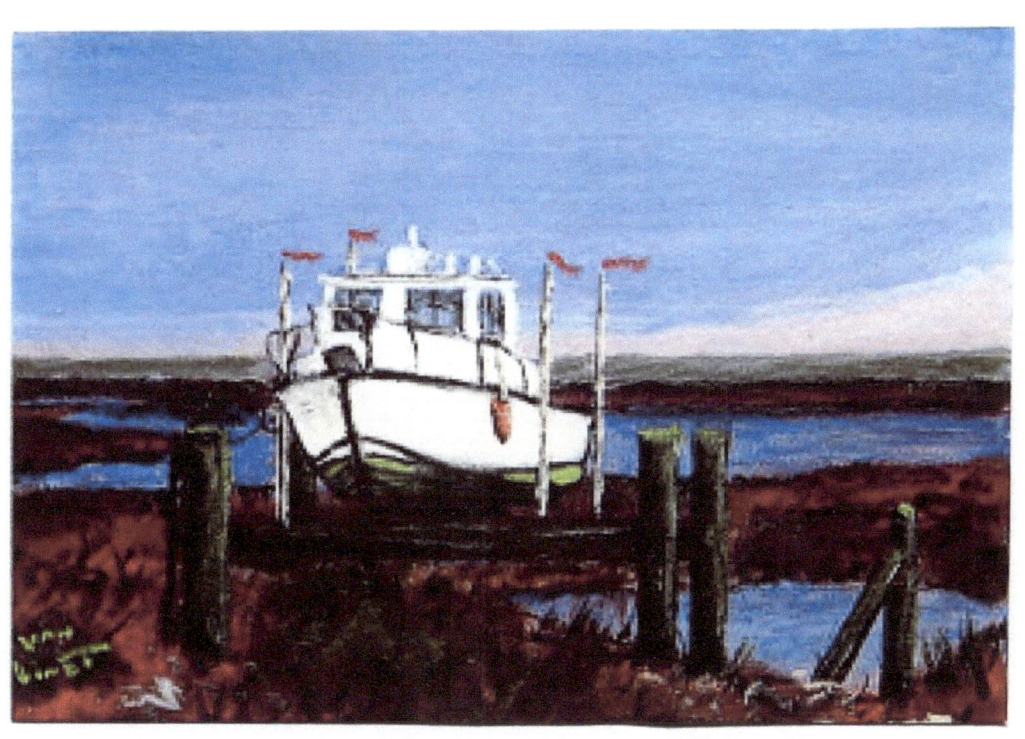

Broad Channel Slip

8x10 acrylic on panel

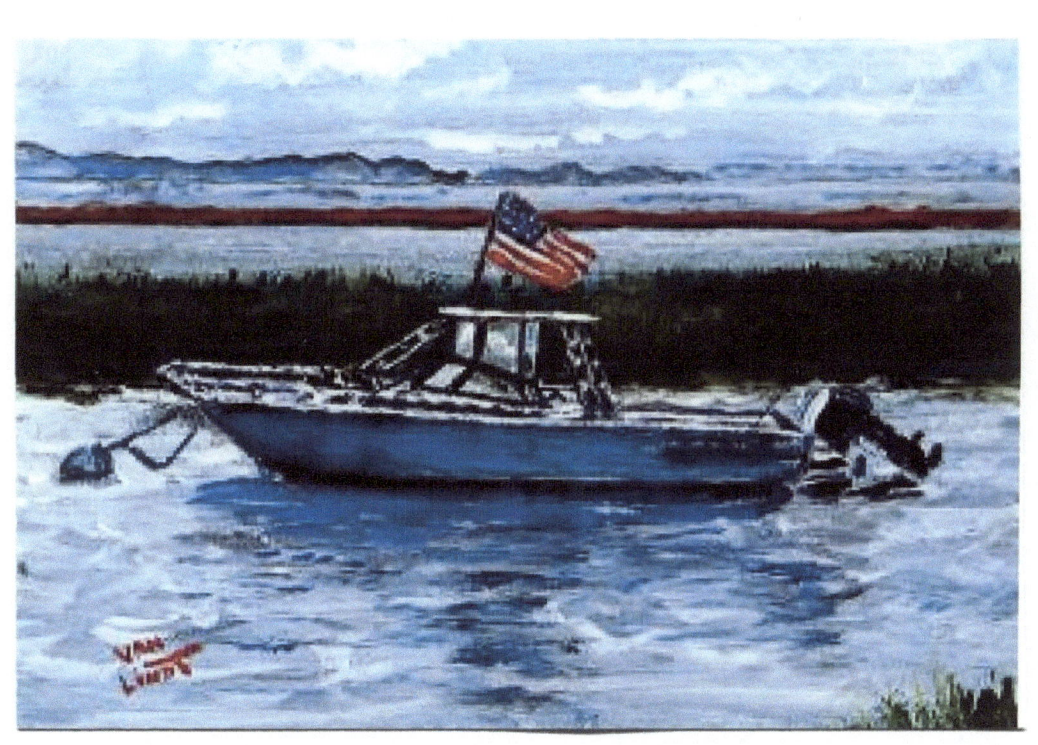

Abandoned in the Marsh

8x10 acrylic on panel

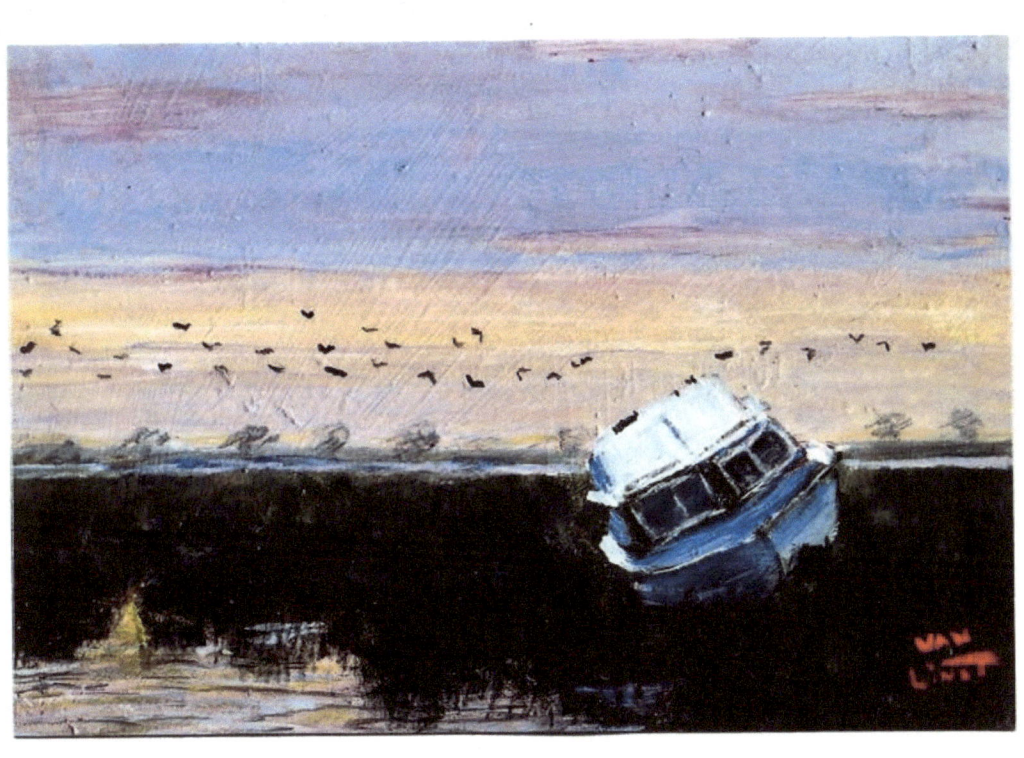

Birch Tree Path I

Jamaica Bay

acrylic on panel

11x14

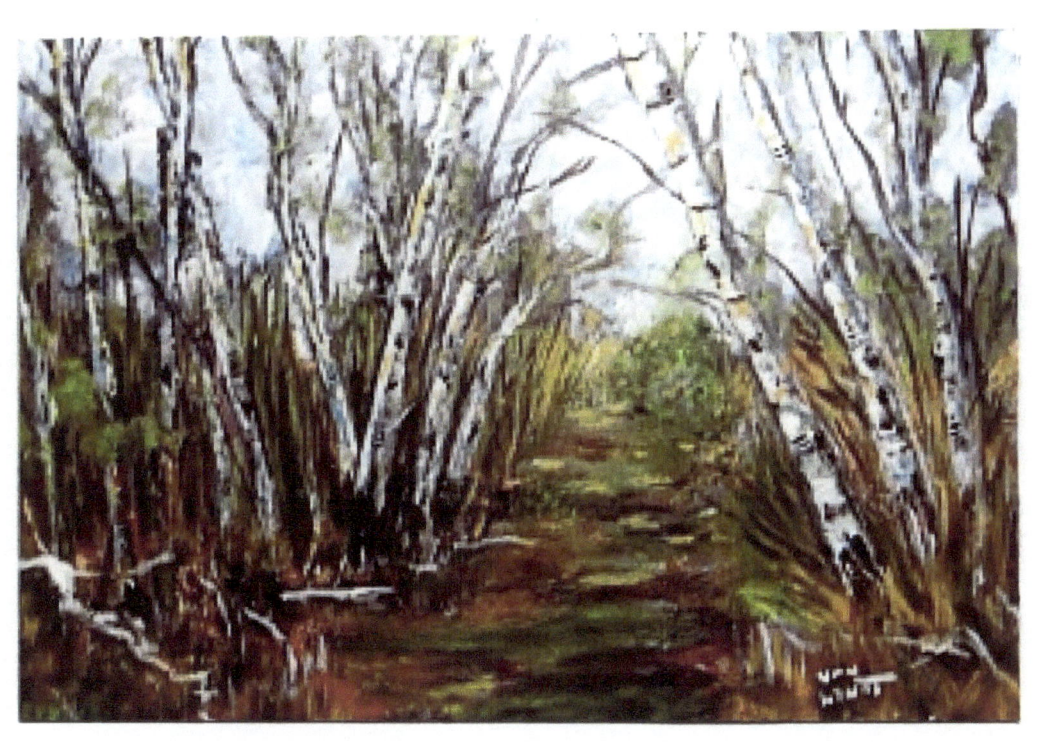

Birch Tree Path II

Jamaica Bay

acrylic on panel

11x14

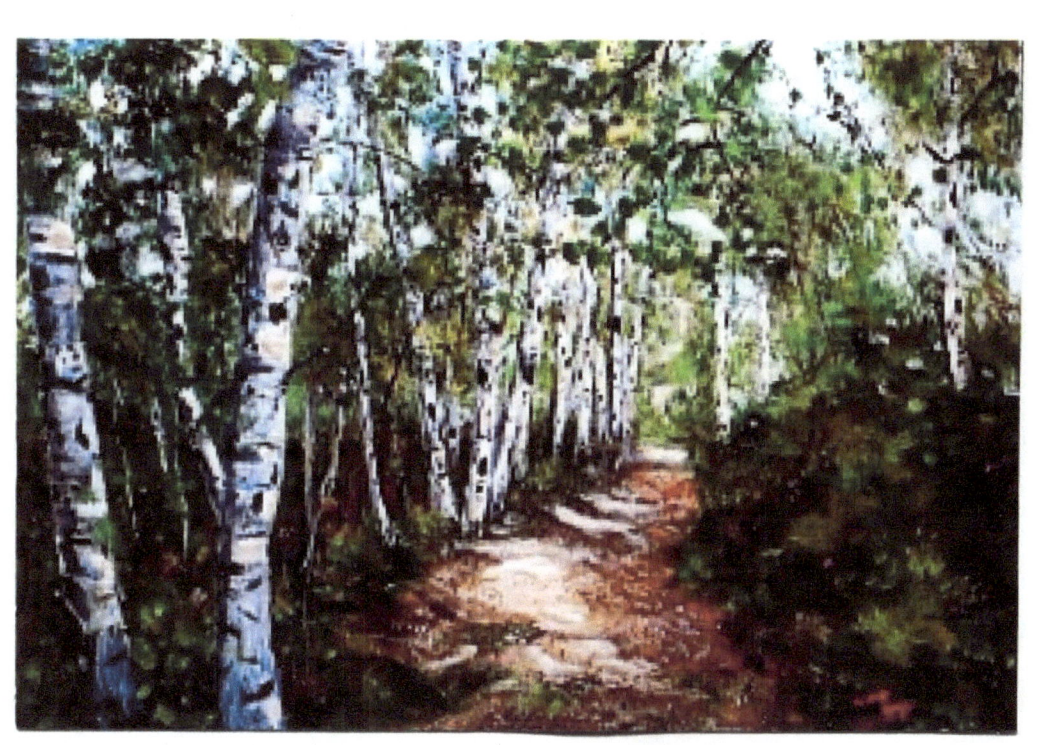

Birch Tree Rhapsody I

20x30 acrylic on canvas

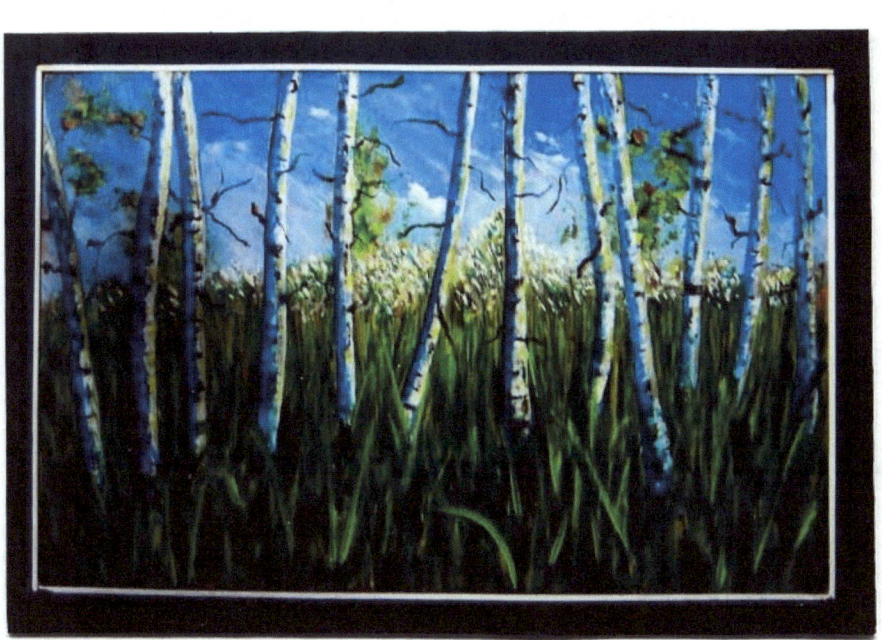

Birch Tree Rhapsody II

11x14 acrylic on panel

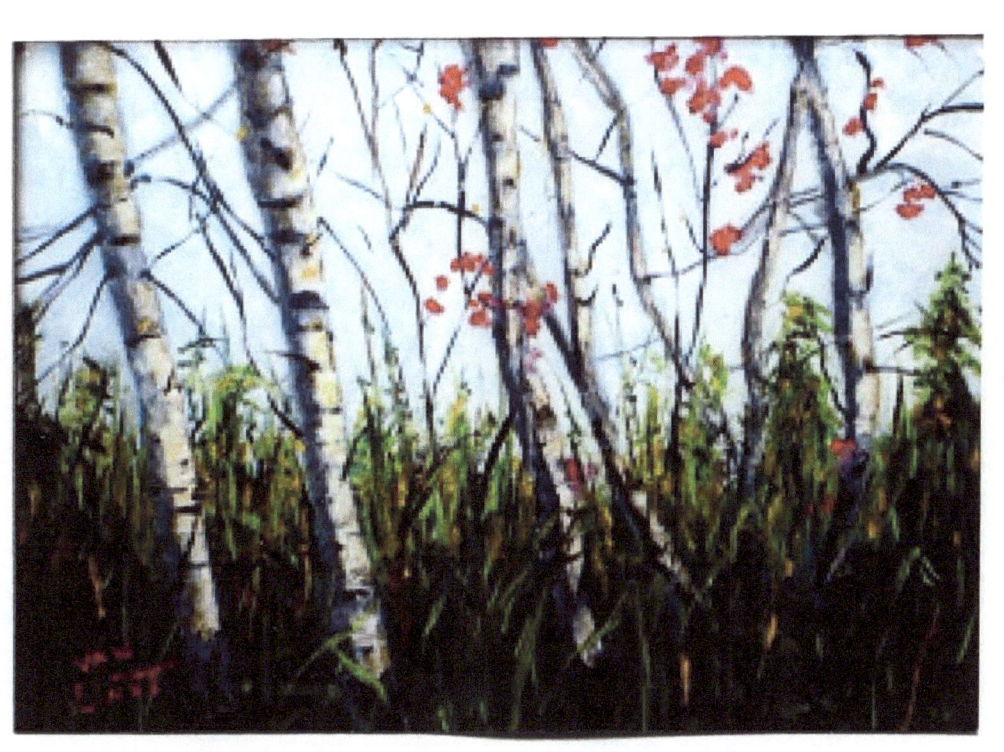

Birch Tree Cluster I

11x14 acrylic on panel

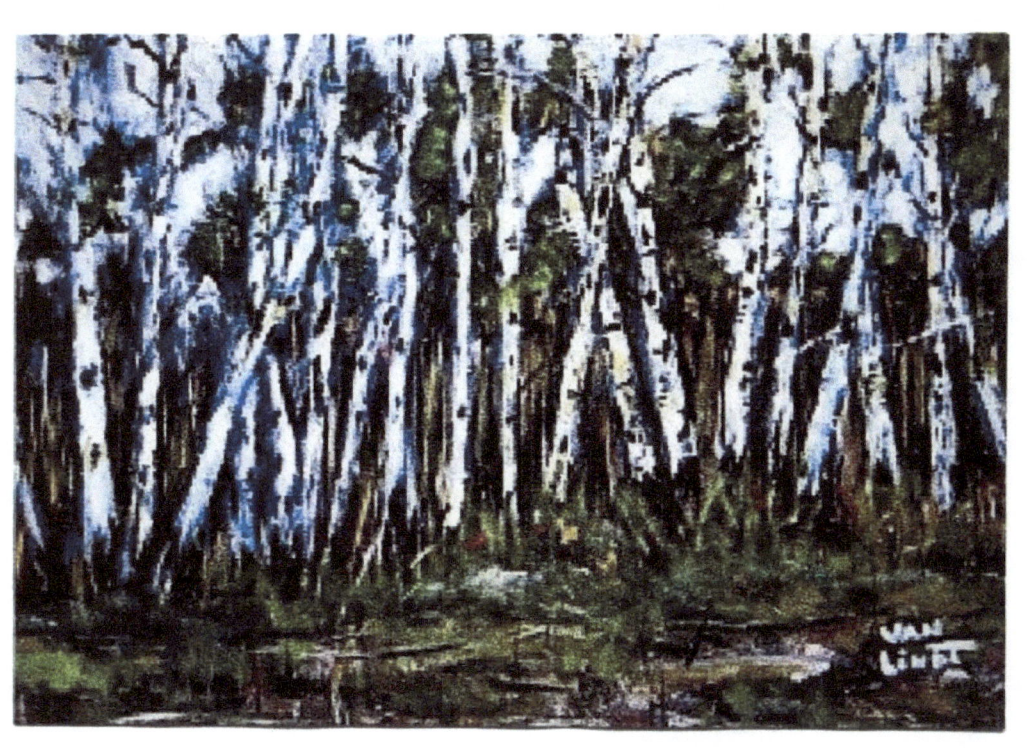

End of Summer Birches

8x10 acrylic on canvas board

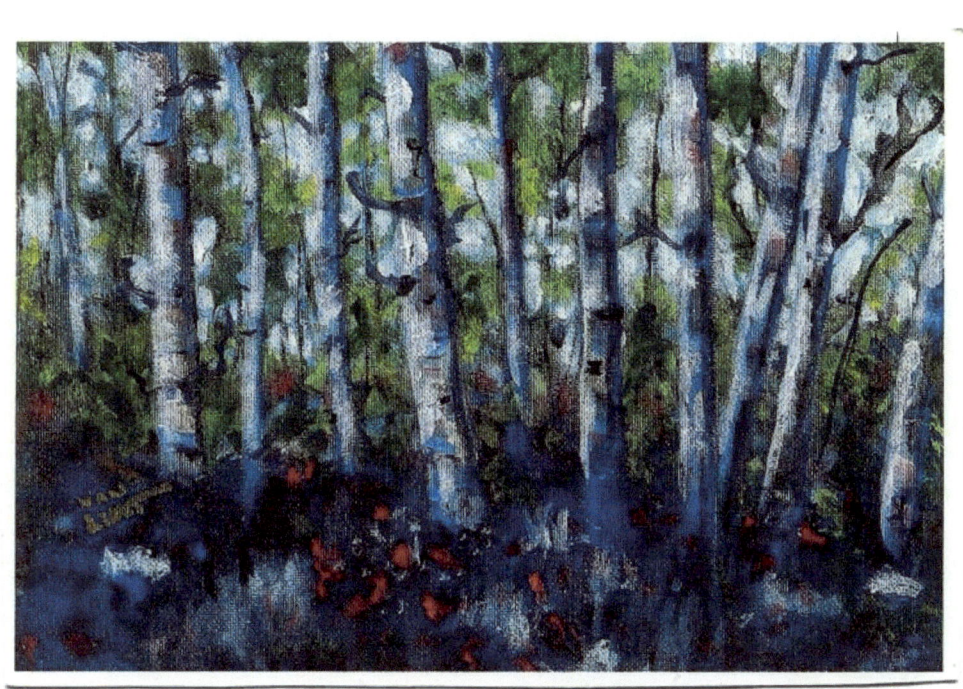

Birch Tree Cluster II

17x22 acrylic on canvas

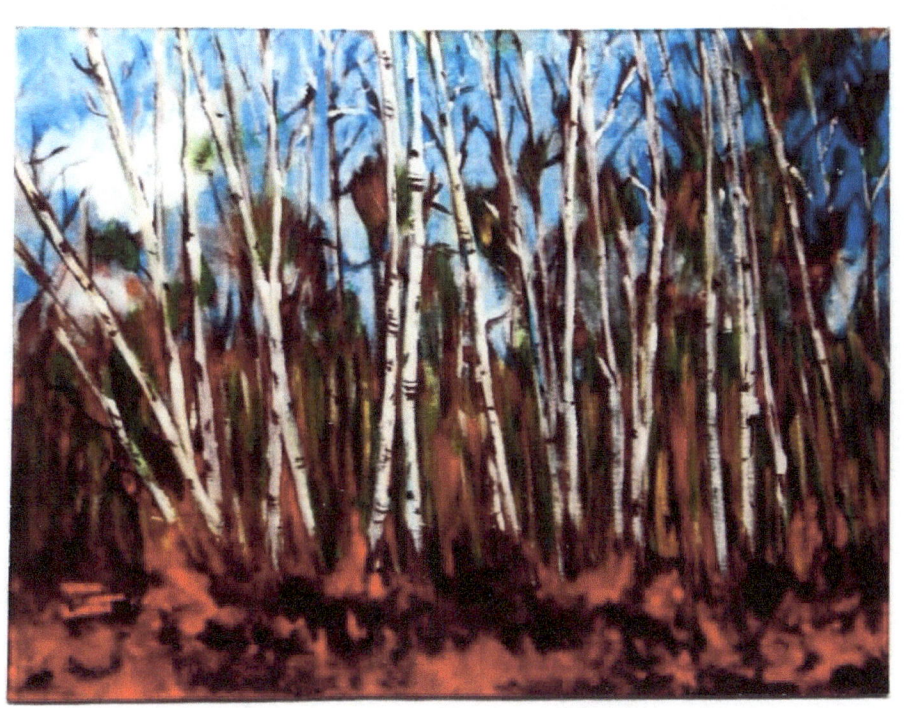

Birches in Plein Air

12x16 acrylic on panel

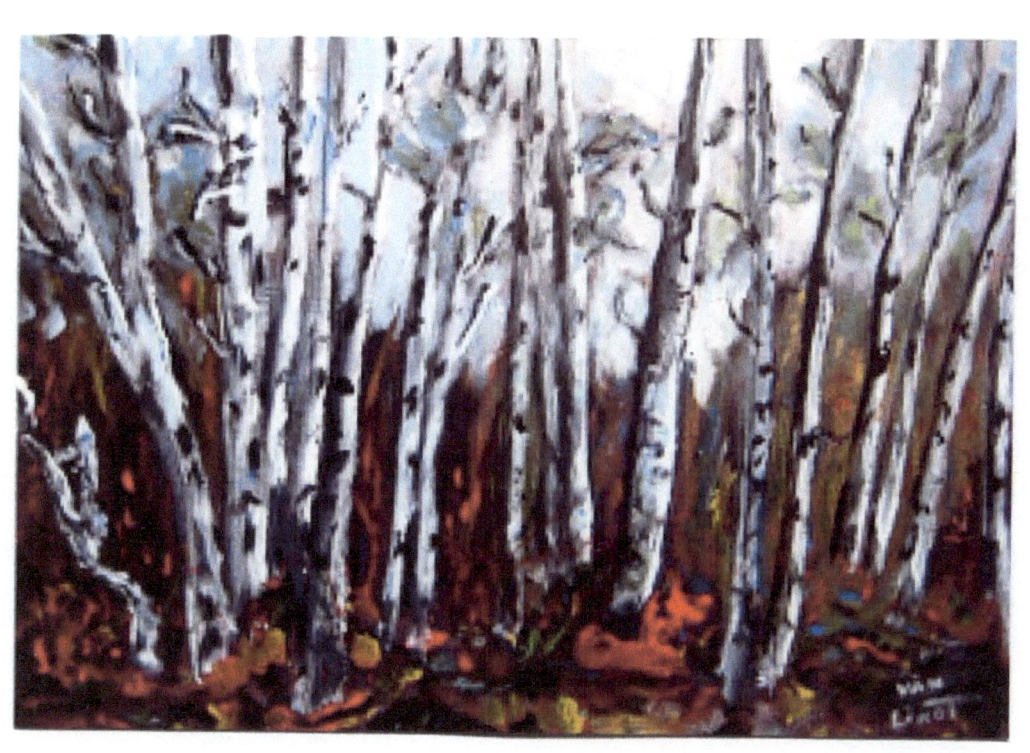

Birch Tree Memoirs

acrylic on canvas

18x24

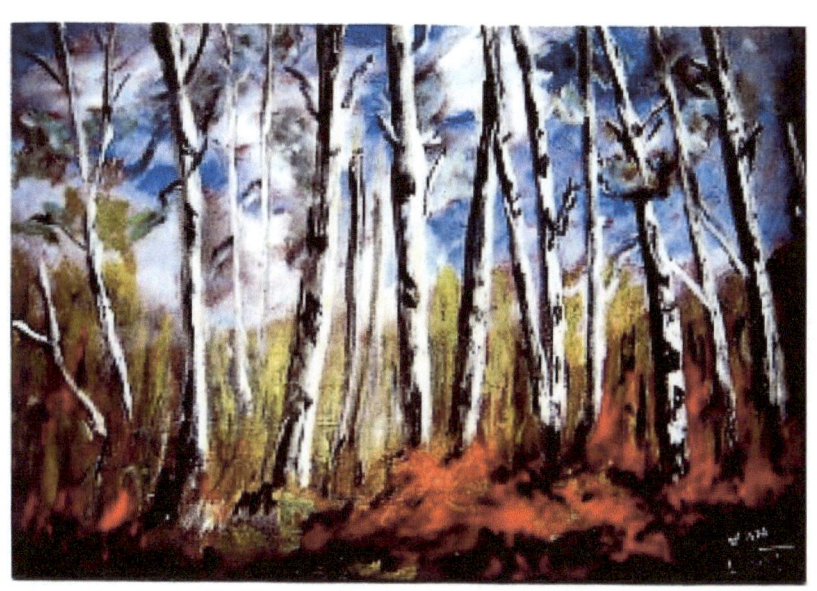

www.ingramcontent.com/pod-product-compliance
Lightning Source LLC
Chambersburg PA
CBHW041204180526
45172CB00006B/1187